SEX DEATH LOVE RELIGION THEATRE DUBSTEP SEX DEATH LOVE RELIGION THEATRE DUBST

WHOLE

PHILIP OSMENT

First performed at Unity Theatre, Liverpool 31 January 2013

WHOLE 2013 TOUR DATES

UNITY THEATRE, LIVERPOOL
1 Hope Place, L1 9BG
Thu 31 Jan – Sat 2 Feb, 7.45pm
Tickets: £10 / £8 / £6
T: 0844 873 2888
www.unitytheatreliverpool.co.uk
*BSL interpreted performance
2 Feb, 7.45pm*

THE BRINDLEY, RUNCORN
High Street, WA7 1BG
Tue 12 Feb, 7.30pm
Tickets: £8
T: 0151 907 8360
www.thebrindley.org.uk

OCTAGON THEATRE, BOLTON
Howell Croft South, BL1 1SB
Mon 25 Feb, 7.30pm
Tue 26 Feb, 2pm & 7.30pm
Wed 27 Feb, 2pm & 7.30pm
Thurs 28 Feb, 5pm
Fri 1 Mar, 2pm & 9pm
Tickets: £10 / £8
T: 01204 520661
www.octagonbolton.co.uk

REDBRIDGE DRAMA CENTRE, LONDON
Churchfields, Sth Woodford,
E18 2RB
Mon 4 March, 2pm & 8pm
Tue 5 March, 2pm & 8pm
Tickets; £9 / £6
T: 020 8504 5451
www.redbridgedramacentre.co.uk

HALF MOON THEATRE, LONDON
43 White Horse Road, E1 0ND
Wed 6 March, 4.30pm & 7pm
Tickets: £6
T: 020 7709 8900
www.halfmoon.org.uk

THE GARAGE, NORWICH
14 Chapel Field North, NR2 1NY
Fri 8 March, 7.30pm
Tickets: £7.50 / £5
T: 01603 283382
www.thegarage.org.uk

NEW WOLSEY STUDIO, IPSWICH
Civic Drive, IP1 2AS
Tue 12 Wed – 13 March, 7.45pm
Tickets: £10 / £5 (Under 26s)
T: 01473 295 900
www.wolseytheatre.co.uk

THE DUKES, LANCASTER
Moor Lane, LA1 1QE
Mon 25 March, 1.30pm & 7pm
Tickets: £8 / £6
T: 01524 598500
www.dukes-lancaster.org

CONTACT, MANCHESTER
Oxford Road, M15 6JA
Thu 28 March, 8pm
Tickets: £10 / £6
T: 0161 274 0600
www.contactmcr.com

There are also performances in schools, youth clubs
and community spaces throughout February and March 2013.

WHOLE
by Philip Osment

CAST
Chantal – **Annabel Annan-Jonathan**
Dylan – **Jacob Beswick**
Joseph – **Joseph Adelakun**
Holly / Nathalie – **Grace Willis**

TEAM
Director – **Julia Samuels**
Designer – **Anna-Marie Hainsworth**
Musical Director / Composer – **Keith Saha**
Lighting Designer – **Douglas Kurht**
Dramaturg – **Lin Coghlan**
Associate Artists – **Curtis Watt, Martin Stannage, Keisha Thompson**
Additional music and lyrics by **Keith Saha, Keisha Thompson, Bradley Thompson, Curtis Watt, Joseph Adelakun, Annabel Annan-Jonathan, Meshach Spooner, Jacob Beswick and Grace Willis**

Production Manager – **Samuel Kent**
Company Stage Manager – **Helen Lainsbury**
Technical Stage Manager – **Jonathan Simms**
Sound Consultant – **Sean Pritchard**
Set Construction – **Samuel Kent for Lobster Productions**
Trailer and Digital Marketing – **Gavin Wood**
Production Photographer – **Robert Day**

For 20 Stories High
Co-Artistic Directors – **Julia Samuels and Keith Saha**
Participation Manager – **Leanne Jones**
Administrator – **Sarah Meath**
Participation Assistant – **Nathaniel Hall**
Business Development Manager – **Isobel Hawson**
Fundraising and Finance Associate – **Tessa Buddle**

DIRECTOR'S NOTE

About six months ago, we talked to writer Philip Osment about writing a play that explored sexuality. The idea had come from conversations we'd been having with our Young Actors Company. Philip agreed to write the play and, like us, wanted to make sure that it was developed with the young people.

At the same time, I was creating a new play with the Young Actors – *TALES FROM THE MP3*. This was a *verbatim theatre* piece – a play that was made up of interviews with the young people themselves – interviews about their lives, their thoughts and their hopes for the future. Philip collaborated with us on this, running initial workshops on verbatim theatre, conducting a couple of the interviews and listening to the material. Our Young Actors are a fantastic group of people; they are funny, intelligent, passionate and opinionated. About half of the group were born in Africa, and the other half here in Liverpool. Our African young people are all committed Christians. Our Liverpool-born young people are much less religious. These interviews inspired the development of *WHOLE*: the themes, the characters and the situations that they find themselves in.

In addition we ran drama-based workshops with the group to explore these themes and held a 'dinner and debate', where we sat together, eating, and talking about religion, sex and sexuality. The young people were extremely open and honest. They had a range of very different perspectives and were happy to challenge and be challenged.

From these conversations, we knew we wanted the play to explore the encounter between our African young people, and their UK-born peers. We wanted it to ask difficult and challenging questions – not to present answers, and definitely not to judge different viewpoints, or preach our own opinions.

So, Philip went away, and created *WHOLE*. What I love most about the play, is that it has a very clear, direct and simple surface, but rippling underneath are very textured and complex situations, themes and questions. With an incredible amount of honesty, humanity and humour, it will give all our audiences a lot to think about.

Philip has been a long-standing mentor, dramaturg and inspiration for many of our plays and projects. I am thrilled and honoured that he has written this fantastic play for 20 Stories High.

I'd also like to say an enormous thank you to all the young people, and to the artists who have shared their creativity in the making of *WHOLE*.

Julia Samuels, January 2013

CAST

Annabel Annan-Jonathan (Chantal)
Annabel trained in musical theatre at Arts Ed and was highlighted as the 'Expert's Choice' by The Stage in their review of her showcase. Since graduating she has appeared in *The Wind in the Willows* (Brockwell Park). Among the roles she played while training are Fr. Bessel and Anna in *Spring Awakening* (which transferred to the Rose Theatre, Kingston), Urleen in *Footloose*, Beth in *Merrily We Roll Along* and Manda in *Babies*. Annabel's credits as a vocalist include a performance with Stevie Wonder at a private concert for Members of Parliament, an appearance at Glastonbury with the band Lazenby, a performance at the Olivier Awards with Arts Ed students and work for BBC Radio One Extra. She is also a member of the Goldsmiths Vocal Ensemble who have performed at the Queen Elizabeth Hall and have worked with the Royal Shakespeare Company.

Joseph Adelakun (Joseph)
Joseph graduated from Rose Bruford College with an Actor Musicianship BA (Hons) in 2011. During his time at Rose Bruford he enjoyed playing characters such as Miles in new play *F**king Instruments* by Nick Payne and Ben Ockrent, Balladeer in *Assassins* and Feste in *Twelfth Night*. He also played Schroeder in Freshcut Productions' *You're A Good Man*, and Charlie Brown at The Camden Fringe. Joseph recently appeared in the Sony Entertainment Commercial – *Little Big Planet VITA*. Recent credits include: *My Body, My Voice* (Schools Tour) and *Run! A Sports Day Musical* (Polka Theatre).

**Grace Willis
(Nathalie / Holly)**
Grace Willis' theatre credits include performances at Soho Theatre, the Battersea Arts Centre, Oval House and a starring role in *The Quick* at Tristan Bates. She has also performed at Scotland Yard and the House of Commons. Grace's TV credits include BBC1 drama *Public Enemies*, starring Anna Friel and the hit BBC comedy, *Derek*, alongside Ricky Gervais.
Grace trained at Identity Drama School and London Metropolitan University.

**Jacob Beswick
(Dylan)**
Jacob Beswick was born and raised in south-east London. He trained with the National Youth Theatre of Great Britain doing many shows at venues such as Soho Theatre and Southwark Playhouse. Jacob took part in one of their social inclusion projects, *Playing Up 2* (2010) and was a member of their first 'REP' company (2012); both were year-long training projects. Jacob has worked with Philip Osment, writer of *Whole*, on National Youth Theatre productions *Shuffle* and *Inside* at the Roundhouse.

CREATIVE TEAM

Julia Samuels – Director

Julia is Co-Artistic Director of 20 Stories High. For 20 Stories High, Julia directed Laurence Wilson's *Blackberry Trout Face*, which won the Brian Way Award 2010, and also the company's first production: hip-hop forum theatre tour *Last Friday*. She has just created and directed verbatim theatre piece *Tales from the MP3* with the Young Actors Company. For the youth theatre, she directed *Rain*, created in collaboration with 84 Theater (Tehran) as part of Contacting the World, as well as site-specific piece *A Private Viewing*. She also co-directed *Dark Star Rising* and *On Me Onez* with Keith Saha and was Associate Artist on *Ghost Boy* and *Babul and the Blue Bear*. Previous to her work with 20 Stories High, Julia worked as Education Producer at the National Theatre, creating a version of *Dr Faustus* for young audiences for the Cottesloe. She also spent 5 years at Theatre Royal Stratford East as Youth Projects Leader.

Philip Osment – Writer

Philip Osment is a playwright, theatre director, dramaturg, teacher and facilitator. His plays include *This Island's Mine*; *The Undertaking* (Gay Sweatshop); *Who's Breaking?* and *Sleeping Dogs* (Red Ladder); *Listen, Wiseguys, Little Violet* (joint winner of the Peggy Ramsey Award) for Theatre Centre; *The Dearly Beloved* (Winner of Writers Guild Award for best regional play), *What I Did in the Holidaying, Flesh and Blood* and *Buried Alive* (for director Mike Alfreds); *Duck!, Of The Terrible Events on the Hamelin* (Unicorn Theatre); *Mad Blud* (verbatim play about knife crime in East London for Theatre Royal Stratford East). His radio plays and adaptations have been broadcast on BBC Radio. Translations include *Pedro The Great Pretender* by Cervantes for the Royal Shakespeare Company; *Kebab* for the Royal Court and *George Dandin* for Graeae.

His reading book for Year 6, *The Lost Gardens,* was published by Harper Collins/Big Cat.

Philip is co-artistic director of Playing ON Theatre Company whose production of his play *Inside* had a sell-out run at The Roundhouse. He is 20 Stories High's writing associate and has been dramaturg on *Blackberry Trout Face, Ghost Boy* and *Tales from the MP3*. He is currently working on Playing ON's next production and a play for Theatre Royal Stratford East.

Anna-Marie Hainsworth – Designer

Anna-Marie trained at the Royal Welsh College of Music and Drama on the MA (Pt1) Theatre Design course achieving Distinction. Recent design credits include National Theatre Wales / Sherman Cymru's *Love Steals Us From Loneliness* (with Neil Davies), a new adaptation of Wedekind's *Spring Awakening* by Gary Owen (directed by George Perrin), *In The Blood* (directed by Charlie Westonra), and new writing performance *Butcher* by Asking 4 It Productions. Anna-Marie has also worked for the Barbican Theatre (Plymouth), Burn-the-Curtain Theatre, Bay Productions and Welsh National Opera, among others. *Whole* is Anna-Marie's first production with 20 Stories High.

Lin Coghlan – Dramaturg

Lin Coghlan is from Dublin. She has written widely for theatre, radio, TV and film. Her plays include *Apache Tears* (Clean Break) which shared the Peggy Ramsey Award; *Kingfisher Blue* (Bush Theatre); *Waking* (Soho Theatre) and *The Miracle* (National Theatre). Her work for the screen includes *First Communion Day* (BBC Films), Winner of the Dennis Potter Play of the Year Award; *Electric Frank* (BBC Films), Winner of the Leopard of Tomorrow at the Locarno Film Festival, and *Some Dogs Bite* (BBC), Winner of the Prix du Public at the Nantes Film Festival. She has written for numerous British and Irish television series and most recently adapted *The Cazalets* by Elizabeth Jane Howard for BBC Radio 4.

Keith Saha – Musical Director

Keith Saha is Co-Artistic Director of 20 Stories High. He started acting in the Everyman Youth Theatre in Liverpool in the 1980s before going on to work professionally with companies such as Graeae, Theatre Centre, Red Ladder, Contact, Theatre Royal Stratford East and Birmingham Rep. He then became a composer for theatre for various companies including Cardboard Citizens,

Theatre Centre and Oval House.

Now a Writer and Director, Keith has been focusing on telling stories through the forms of Hip-Hop Theatre with Puppetry and Mask. In 2010, he was awarded The Brian Way Prize for the UK's Best New Play for Young People for his play *Ghost Boy* (a co-production with Contact and Birmingham Rep), which championed this form. He also writes and develops plays with 20 Stories High Youth Theatre including *RAIN* (2010), *The Bulldozer Urban Cabaret* (2011), and *The Universe and Me* (2012).

Douglas Kurht – Lighting Designer

Douglas Kurht is a lighting designer and recent designs include: *Jack & The Beanstalk* (Liverpool Playhouse); *The Blue Boy* (New Writing North); *Take Me With You, Road Movie* (Starving Artists); *Broadway Enchanté* (Paris); *Jigsy* (Edinburgh) and *Rain Man* (Frankfurt). He has also designed for *The Pitmen Painters* (Duchess, National & Broadway); *Little Voice* (Hull Truck); *Witness For The Prosecution* (Bill Kenwright Ltd); *Piccadilly Revisited* (Linbury); *Cinderella!* (Liverpool Playhouse); *Aladdin* (Liverpool Everyman); *Educating Rita* (Citizens, Glasgow); *Geoff Dead:*
Disco for Sale (Live); *Depth Charge* (Gecko); *King Lear* (Yellow Earth, Shanghai); *The Deranged Marriage* (Rifco); *Zipp!* (Duchess); *Pinocchio* (Polka); *Fascinating Aida* (Haymarket); *Dreaming* (Queen's) and *Naked Justice* (West Yorkshire Playhouse).

Samuel Kent – Production Manager

Samuel Kent has worked in a variety of touring and in-house technical, production and stage management roles with a wide range of companies including English Shakespeare Company International, Out of Joint, BBC, National Dance Company of Ireland, Liverpool and Merseyside Theatres Trust, Liverpool Scenic Workshop and Base Chorus. He currently directs a company providing production support to the cultural and entertainment industries. Clients include Unity Theatre, Saville AV, Blitz Communications, Ear To the Ground, Manchester Pride, and 20 Stories High.

Helen Lainsbury – Stage Manager

After graduating in 2008 with a BA Honours in Theatre and Performance Technology from the Liverpool Institute of Performing Arts, Helen worked extensively as a freelance Stage Manager. Helen is delighted to be back in the UK after nine months working in Australia and is looking forward to taking this excellent work across the country to some fantastic venues.

Theatre Credits include: *Jack and the Beanstalk* (Liverpool Playhouse); *Diving For Pearls* (National Australian Tour for Hit Productions); *Cinderella* (Nottingham Playhouse); *Eight Miles High; Good Golly Miss Molly; Carbon Copy Building; The End of Cinematics* (all Royal Court Liverpool).

Television Credits include: Channel Seven's *Victorian State School Arena Spectacular* (Melbourne, Australia).

Festival and Event Credits include: *The Write Now Festival* at the Actors' Studio Liverpool.

Jonathan Simms – Technical Stage Manager

Jonathan studied at the Liverpool Institute for Performing Arts (LIPA) and graduated with a First Class Honours Degree in Performance Technology. He is currently working within both live events and theatre. Recent roles include Assistant Project Manager on the *Liverpool Giant Spectacular – a Sea Odyssey*, Show Caller on Liverpool's *Hillsborough City Vigil* and various work with Liverpool Playhouse Theatre and dBS Solutions (sound and lighting hire company).

SIGNPOSTS

If you would like further support about any of the issues raised in the play please contact:

YoungMinds: www.youngminds.org.uk / 0808 802 5544
YoungMinds are the UK's leading charity committed to improving the emotional wellbeing and mental health of children and young people.

Albert Kennedy Trust: www.akt.org.uk/ 0161 228 3308
AKT supports young LGBT 16-25 year olds who are made homeless or living in a hostile environment.

Stonewall: www.stonewall.org.uk / 0800 050 20 20
Stonewall work for equality and justice for lesbians, gay men and bisexuals.

GYRO: www.gyro.org.uk / 0151 707 1025
GYRO (Gay Youth 'R' Out) is Liverpool's youth group for young people aged 13 to 25 who are lesbian, gay, bisexual, transexual, or questioning (LGBTQ).

ChildLine: www.childline.org.uk / 08001111
ChildLine is a free 24-hour counselling service for children and young people up to their 19th birthday in the UK, provided by NSPCC.

Missing people: www.missingpeople.org.uk / Freefone 116 000
Missing People offer a lifeline for people who run away and go missing, providing specialised support to ease the heartache and confusion, and help search for missing loved ones.

THANK YOU

20 Stories High would like to thank: the teams at The Bluecoat, Liverpool Everyman and Playhouse, and the Unity Theatre; Leon Tagoe, Modupe Adeyaye, Tara Hodge, Vanessa Babirye, Anita Welsh, Toyin Otubusin, Annie Mukete, Bradley Thompson and all the Youth Theatre and Young Actors Company, Mark Powell, Toxteth TV, Alex Herring, Nicole May, Lisa Davies, Ruth Samuels, Curtis Watt, Alice Foxall.

And to *Whole* social partners: GYRO (Gay Youth 'R' Out) and Albert Kennedy Trust.

And to *Whole* funders: Arts Council England, Liverpool City Council, Paul Hamlyn Foundation, Esmee Fairbairn Foundation.

FREE AUDIENCE ACTIVITIES

At 20 Stories High we are keen to connect with our audiences, partners and participants. With WHOLE, there are a whole host of ways you can connect with us artistically and also engage in conversations about the show.

Digital Activity: A Game of Tag

20 Stories High are running a Facebook Digital Game "A Game of Tag" while WHOLE is on tour.

The RULES:

1. "Like" our 20 Stories High Facebook community page: **tinyurl.com/20shonline**

2. We will invite you to become a friend of "Whole A GAME OF TAG"…

3. We tag you, and you join A Game of Tag… you get to share your thoughts and ideas with other audience members from all over the country…

Post-show discussion: With the actors, exploring the themes and issues in the play, and the making of the production.

Programme and signposting information: 20 Stories High will be handing out programmes at the end of the production, with information about WHOLE and how to get involved with 20 Stories High in the future.

Resource Pack: This free pack will be available online for any school or community group. It will feature key information about the show, company and production team. The pack will also offer activities and ideas for groups to explore in the classroom or during session time.

For more information please contact our Participation Manager, Leanne Jones: **leanne@20storieshigh.org.uk / 0151 708 9728.**

Everybody has a story to tell and their own way of telling it...

20 Stories High was established in 2006 and is led by Co-Artistic Directors Julia Samuels and Keith Saha. We create bold, contemporary and imaginative theatre with and for young people aged 13-30. Our home is in Toxteth, Liverpool, but our reach is regional, national and international. We are passionate about pushing the boundaries of what theatre is and what it means to young people.

We are committed to ensuring that young people from excluded communities have access to high quality, engaging and inspiring theatre, and that their skills, knowledge and confidence about the performing arts are able to flourish. We work in partnership with theatres across England to bring young and culturally diverse audiences into their venues. We also tour our work into schools and youth clubs.

We have won a number of prestigious awards. In 2011 *Ghost Boy* (by Keith Saha) won the Brian Way Award for the UK's Best New Play for Young People, as well as the 2010 Best Touring Production from the Liverpool Daily Post Awards. *Blackberry Trout Face* (by Laurence Wilson) received the 2010 Brian Way Award for UK's Best New Play for Young People, and was also shortlisted as Best New Play by the Manchester Evening News 2009.

In Autumn 2013, 20 Stories High will tour Melody Loses Her Mojo by Keith Saha, a groundbreaking fusion of hip-hop theatre with masks and puppetry, following the amazing journeys of three remarkable young people. Touring to mid-scale venues nationally, in co-production with Liverpool Everyman and Playhouse and Leicester Curve.

Stay in touch

You can stay connected with 20 Stories High by visiting our website, where you can view all of our current and past productions, find out more about our participatory work, view 20 Stories High TV…

WEBSITE www.20storieshigh.org.uk

NEWSLETTER Sign up here: 20storieshigh.org.uk/sign-up/

You can also find us on Facebook, Twitter, YouTube, Soundcloud, Pinterest and Flickr!

FACEBOOK Join 20 Stories High Community Page

TWITTER Follow us @20storieshigh #wholetheplay

YOUTUBE www.youtube.com/user/20storieshighTV

SOUNDCLOUD www.soundcloud.com/20storieshigh

PINTEREST 20 Stories High

FLICKR 20 Stories High

Funders and Partners

20 Stories High are grateful to the following for their support: Arts Council England, Liverpool City Council, Paul Hamlyn Foundation, Esmee Fairbairn Foundation, Lankelly Chase, BBC Children in Need, Garfield Weston, Trusthouse Charitable Foundation, Liverpool Everyman and Playhouse Theatres, The Bluecoat, Toxteth TV, Kate Samuels, Lloyds TSB Banking Group Foundation, The Co-Operative Bank Customer Community Fund, The Co-Operative Bank Community Fund, E.L Rathbone, Eleanor Rathbone, Supporters during The Big Give Christmas Challenge

Participation

20 Stories High offer a diverse programme of workshops and discussion for young people.

Board

PAST PRODUCTIONS

Professional Touring

2006 *Last Thursday* by Keith Saha
2007 *Slow Time* by Roy Williams
2008 *Babul and the Blue Bear* by Keith Saha
2009 *Blackberry Trout Face* by Laurence Wilson
2010 *Ghost Boy* by Keith Saha
2011 *Blackberry Trout Face* by Laurence Wilson

Youth Theatre and Young Actors Productions

2008 *Dark Star Rising* (in collaboration with Urbeatz)
2008 *A Private Viewing*
2009 *On Me Onez*
2010 *Rain* (in collaboration with 84Theater, Tehran)
2011 *Bulldozer Urban Cabaret*
2012 *The Universe and Me*
2012 *Tales from the MP3* (Young Actors Company)

Philip Osment

WHOLE

OBERON BOOKS
LONDON

WWW.OBERONBOOKS.COM

First published in 2013 by Oberon Books Ltd
521 Caledonian Road, London N7 9RH
Tel: +44 (0) 20 7607 3637 / Fax: +44 (0) 20 7607 3629
e-mail: info@oberonbooks.com
www.oberonbooks.com

A catalogue record for this book is available from the British Library.

PB ISBN: 978-1-84943-445-4
E ISBN: 978-1-84943-814-8

Cover image by Depositphotos / Oleksandr Lishchinskyi

Printed, bound and converted
by CPI Group (UK) Ltd, Croydon, CR0 4YY.

Visit www.oberonbooks.com to read more about all our books
and to buy them. You will also find features, author interviews and
news of any author events, and you can sign up for e-newsletters
so that you're always first to hear about our new releases.

CHARACTERS

DYLAN
19, unemployed also playing himself at 15

CHANTAL
19, taking a gap year also playing herself at 15

JOSEPH
19, an engineering student originally from
Nigeria also playing himself at 15

NATHALIE
20, an actress playing **HOLLY** at 15

Note

I have watched with admiration as Julia and Keith have built up the work and reputation of 20 Stories High over the last six years with integrity and rigour and I have enjoyed enormously my visits to Liverpool as dramaturg on some of the productions. So it has been a great pleasure to collaborate with the company more closely as playwright. As Julia acknowledges in her director's note, WHOLE has come out of a process of collaboration with the youth theatre and the young company whose insights, experiences, wisdom and wit have been an inspiration for the writing – any shortcomings are all my own!

The conceit of the play is that three young people have approached the producing company (in this case 20 Stories High) and worked with the director (in this case Julia Samuels) to put on a play about their friend Holly. They have auditioned and cast a fourth person (an actress called Nathalie) to play Holly. When towards the end of the performance, one of them stops the play to reveal something, the audience should think that this is unrehearsed and spontaneous.

Square brackets indicate who the actors can address when they stop the play. If the director, Julia, is not in the audience, the actors address the Stage Manager instead.

There are also alternative references to the time of day of the performance in square brackets ('today' and 'tonight'), which are to be used accordingly.

The chronology of events have been worked out to support the conceit – the characters are performing the play in the present (currently Spring of 2013) when they are nineteen which dictates the dates of earlier scenes. Musical references and the level of sophistication of technology (mobile phones, bluetooth etc.) are in keeping with those timings and might need to be updated for future productions.

For information about music used in this production, please contact 20 Stories High.

I would like to thank Julia and Keith for their unflagging support and feedback during the process, Lin Coghlan for her wise counsel as dramaturg, Mike Alfreds for responses to the script and Nina Ward for helping to remove writer's block at points along the way.

Lastly I want to express gratitude to the Royal Literary Fund for generous support in recent months.

Philip Osment, January 2013

PROLOGUE

The actors sing this song and share the verses between them as appropriate.

Sometimes I feel empty,
Fill myself with the things I should not take,
Taste the things that I want to taste,
But I never feel like I'm really
Whole.

What's the matter with her face?
Why does she look like she's always out of place?
Like the moon in the daytime.
Can't tell…if she's really
Whole.

Let me be what I want to be.
Hold me, whole-heart-edly.
I'm like the apple that's fallen from the tree.
Pick me up and always
Hold
Me
Close.

Hold

I'll come running when you call,
Stop you from drowning in the sea.
I'll let you be who you want to be.
I'll catch you before you fall in a
Hole

(Falling in a)	Hole	
(Make me feel)	Whole	
(Always)	Hold	(me close)

(Rap.) These are the days – you don't wanna go solo,
Sitting in a hole, feeling down, feeling so low,
You end up digging deeper, digging deeper down

Till everything feels like it's upside down.
I wanna move on – I'm looking for my sequel,
But I'm always backsliding like I'm stuck in a prequel,
Got myself in a hole, but I wanna feel whole.
I'm like the living dead and I'm looking for my soul.

1 INTRODUCTION

DYLAN, CHANTAL, JOSEPH *and* NATHALIE/HOLLY

DYLAN: Hello everybody…ummmm…we're from 20 Stories High and we've come here today to tell you about our friend Holly who we went to school with. I guess we should introduce ourselves first. My name's Dylan and this is –

JOSEPH: Yes, my name is Joseph. Hello.

CHANTAL: Hi, I'm Chantal.

NATHALIE: And my name's Nathalie.

DYLAN: Nathalie's an actress/ who's going to play –

JOSEPH: /A fantastic actress.

NATHALIE: /Thank you Joseph.

DYLAN: /Yes she is fantastic. Nathalie didn't go to school with us but we've got her in to play Holly. I'm just going to say a few words about why we're doing this show umm. We've been rehearsing for the last few weeks with Julia our director [who's sitting over there] and we've put together some scenes and some lyrics

JOSEPH: And some music

DYLAN: Yes and music umm because we thought that this is a story that it's important for people to hear. Especially people at school who might be going through some of the stuff that we were going through at the time. Anyway so

like I said, Chantal, Joseph and me went to school with Holly.

JOSEPH: Back in the day –

DYLAN: Yeah, it's um four years ago now. We've all left school now and for various reasons we found that we had some free time –

CHANTAL: We're unemployed.

DYLAN: Yes, I was unemployed and Chantal is taking a gap year and Joseph's waiting go to Uni ummm so I thought we could do this show. So I got back in touch with these guys and they agreed it was a good idea. So then we approached Julia and 20 Stories High about putting it on. Luckily Julia thought it was a good idea too.

NATHALIE: And you auditioned me.

DYLAN: Yes, we held auditions and –

JOSEPH: And Nathalie came along and we thought she was fantastic.

DYLAN: And so yeah here we are.

CHANTAL: So Dylan tell us how you know Holly.

They all laugh at her blatant attempt to get him to move on.

DYLAN: Yes. I actually knew Holly from nursery. We lived quite close to each other and hit it off right from that time really. We ended up going to the same Primary School and um as far as I knew, everything in her life was ok. But actually there was stuff going on at home that I didn't really know about. Her Dad wasn't around and so it was just her and her Mum. And one day my uncle – yeah um – my uncle worked up at the hospital in the psychiatric unit and one day he said something about Holly's Mother being in there – in the ward for people with like mental problems. Anyway I said something to Holly about it and she went bananas – she didn't speak to me for the rest of

the term. So after that we didn't talk about it and we made friends again. Then we went to Secondary School together.

CHANTAL: Where you met me!

DYLAN: Yes where we met Chantal. By that time Holly was in care but social services worked it so that she could keep coming to the school. She had a few different foster homes but always like in the area, so we didn't even know she was in care. She didn't talk about it – she didn't ever invite people back for a sleepover or anything. So anyway, yes, we met Chantal in umm…

CHANTAL: Year 8.

DYLAN: In 2006.

CHANTAL: Yes so it was in drama – our first drama class after the summer and the teacher got us into groups and told us to make a still picture of something that happened in the holiday. I'd been on the London Eye because my Aunty came over for a visit from Cameroon and it turned out that Holly had been on the London Eye that summer too and so we said yeah, let's do that. But Dylan was going –

The following altercation is good-humoured. They have rehearsed it with Julia who has thought it would be engaging for the audience to see them arguing like this.

DYLAN: – I didn't want to do that –

CHANTAL: He wanted to do some/ James Blunt concert

DYLAN: I thought the London Eye was/ a pretty boring idea.

CHANTAL: *(Sings.)* You're beautiful!

DYLAN: I wanted to be him and them to be my adoring fans at the Koko Club –

CHANTAL: He hadn't even been to a James Blunt concert/ he'd just seen him on YouTube.

DYLAN: /Ooooh look, there's the Houses of Parliament! Big deal!

CHANTAL: So anyway he was outvoted and after that Holly and me became best friends.

DYLAN: And that day after school we went down the graveyard to hang out –

CHANTAL: Holly was just beginning to write lyrics and I liked singing –

DYLAN: She had this book where she used to write down all her ideas –

NATHALIE holds up a brightly coloured A4 notebook.

DYLAN: Yeah, that's the actual one.

CHANTAL: So we went down the graveyard and –

JOSEPH: You jammed?

DYLAN: Kind of.

NATHALIE/HOLLY, CHANTAL and DYLAN move forward.

2 JAMMING IN THE GRAVEYARD IN YEAR 8

September 2006.

CHANTAL: It's a bit spooky down here.

DYLAN: That's the point. It keeps the chavs away.

HOLLY: Snob!

CHANTAL: Eee look at this gravestone. This girl died at the age of 15. That's really sad that.

HOLLY: Yeah Samantha Barnes – condom girl.

CHANTAL: What?

HOLLY: We found a condom on top of her last term.

CHANTAL: That's disgusting.

HOLLY: It wasn't a used one. It was probably Flakey Blake. He blew one up in the playground.

CHANTAL: I thought you said the chavs don't come down here.

DYLAN: HERE IN THE GRAVEYARD WITH THE GRAVES AND THE BONES

HOLLY: HERE IN THE GRAVEYARD WE CAN BE ON OUR OWNS

CHANTAL: I HOPE I DON'T START HEARING GROANS AND MOANS

HOLLY: HERE IN THE GRAVEYARD WE CAN GET IN THE ZONE

DYLAN: WE CAN GET IN THE GROOVE AND HIT THE RIGHT TONE

CHANTAL: TO BE HONEST I'M GLAD I'VE GOT MY MOBILE PHONE

They laugh.

HOLLY: THIS IS CHANTAL
SHE'S MY PAL

DYLAN: SHE'S THE GIRL

CHANTAL: I'M THE GIRL

HOLLY: SHE'S NEW TO OUR TEAM BUT SHE'S DOING VERY WELL

CHANTAL: THIS IS DYLAN
HE'S NO VILLAIN

HOLLY: HE CAN'T REALLY RAP BUT HE'S STILL WILLING

DYLAN: Very funny.

CHANTAL: THIS IS HOLLY
SHE'S VERY JOLLY

DYLAN: I'VE KNOWN HER FOR YEARS AND SHE'S OFF HER TROLLEY

CHANTAL: You always hang out together, don't you?

DYLAN: Yeah we're old friends.

CHANTAL: *(To HOLLY.)* You nearly got expelled last year, didn't you?

HOLLY: Yeah I had a fight with Ashley Barnes.

CHANTAL: Oh yeah.

HOLLY: He put a coke can of urine in Dylan's locker. No-one does something like that to one of my friends and gets away with it.

DYLAN: She's like my big sister!

HOLLY: I've got his back. He's got mine. That's all.

HOLLY: CHECK ME OUT

DYLAN: CHECK US OUT

CHANTAL: CHECK HER OUT

DYLAN: CHECK US OUT

HOLLY: THIS IS OUR TEAM

DYLAN: THIS IS OUR TEAM

CHANTAL: THIS IS YOUR TEAM

HOLLY: YOU CAN JOIN US IF YOU WANT
YOU CAN BE IN OUR TEAM

DYLAN: YOU CAN BE IN OUR TEAM

HOLLY: THIS IS OUR TEAM

DYLAN/CHANTAL: THIS IS OUR TEAM

HOLLY: WE'RE TOO COOL FOR SCHOOL

DYLAN: CHECK US OUT

CHANTAL: WE'RE TOO COOL FOR SCHOOL

HOLLY/DYLAN: CHECK US OUT

CHANTAL: WE'RE TOO COOL FOR SCHOOL

HOLLY/DYLAN/CHANTAL: WE'RE TOO COOL FOR SCHOOL!

JOSEPH: Well, the truth is that they were not very cool at all as you can see! They needed someone with some style to join them. Which is what happened in Year 10 when I brought them my magic.

DYLAN: Yeah sure! So yes, Joseph came to the school in Year 10. By that time Holly was back living with her Aunty.

3 NATHALIE READS FROM HOLLY'S BOOK

2008.

HOLLY: *(Reading from HOLLY's book.)* I hate her. I hate her. Yes Aunty Becky, I'm talking about you! As soon as I walked through the door tonight, she was on my back again. Making out I broke the lid off the pedal bin when I bet it was brat child who can never do no wrong in her eyes. I didn't even touch the pedal bin. Making me do the washing up when it ain't my turn – as a punishment. Cow. Cow. Why did she bring me to live with her if she didn't want me here? Chatting breeze about me coming back to the loving arms of the family. And I thought yeah maybe! Maybe I'll get to see my Mum. **Which hasn't happened!** Aunty B only wanted me so she could collect the allowances – she looks at me and sees extra cash. People always let you down. Like the McBrides – my first foster parents – buying me new clothes and fluffing the pillows and then two twos they're ringing social services whining about me having anger problems. I'm not going to lie – I did hit my foster brother – I was teaching him one of life's lessons – don't talk about a person's Mum unless you want to get slapped. So it's back to Athlone House and more assessments and yackety yacking social workers. And then just when I get some foster parents I can roll with – Joanne and Derek were really nice – my fat cow of an Aunty comes waddling into my life again. Hope she is reading this.

Aunty Becks is always trying to vex me and hex me and next she say No wonder my Mum don't text me cos I'm extra out of control. Manipulative Cow. Don't know how I'm going to keep my cool. Thank Christ for school where friends rule. Chantal and Dylan remind me who I am, we stick together like jam, like mash potatoes and yam, like mint sauce and lamb, we're the grand slam and we don't give a damn for shams, it's no slam bam thank you Mam kind of friendship cos they're my real fam, my fam from the street and Aunty Becky's just spam – delete, delete, delete.

4 JOSEPH MAKES NEW FRIENDS

January 2009. They sit on four chairs: DYLAN and JOSEPH are sitting next to HOLLY and CHANTAL.

JOSEPH: *(To HOLLY.)* Excuse me, can I borrow your eraser?

HOLLY: What?

JOSEPH: I've made a mistake and I want to erase it.

HOLLY: I can't understand a word you're saying.

DYLAN: He wants to borrow your rubber.

HOLLY: Well, why didn't he say so?

DYLAN: He did. Eraser's the proper word for rubber. Here, have mine.

JOSEPH: Thank you. Rubber.

HOLLY: That's the proper English word.

JOSEPH: Where are you from?

HOLLY: What you mean? England.

JOSEPH: What is your ethnic origin?

HOLLY: You what?

DYLAN: Her Dad was from Trinidad but her Mum's English.

HOLLY: What's it to you?

JOSEPH: I'm Joseph and I'm from Nigeria.

(To CHANTAL.) What about you?

HOLLY: She's from here too.

CHANTAL: I'm from Cameroon originally.

JOSEPH: Ah Cameroon! We are African neighbours.

HOLLY: *(Mimicking.)* We are African neighbours!

CHANTAL: I'm Chantal.

JOSEPH: It's a pleasure to meet you Chantal.

HOLLY laughs at his style.

DYLAN: I'm Dylan.

JOSEPH: Dylan! Like Bob Dylan. I know this name. Dylan, my first friend in England. Thank you Dylan for letting me use your rubber.

HOLLY: Eughh! They've been sharing rubbers.

JOSEPH: Huh?

DYLAN: Ignore her.

HOLLY: You know what a rubber is?

DYLAN: Hol!

HOLLY: It's a condom. You probably don't have them in Nigeria.

JOSEPH: Yes we have condoms. In Trinidad maybe there are not so many.

DYLAN: Pow Pow!

HOLLY: Shut up Dylan.

CHANTAL: I think you go to my Church.

JOSEPH: Yes?

CHANTAL: I saw you last Sunday.

JOSEPH: Yes? I didn't see you. I think I would have noticed you.

HOLLY: Ooooooohh!

CHANTAL: I'm in the choir.

JOSEPH: Ah I could not see the choir from where I was sitting.

DYLAN: So all three of you go to that Church.

JOSEPH: We do?

CHANTAL: Holly comes with me sometimes.

DYLAN: Chantal's converted her.

HOLLY: I like it.

CHANTAL: You should come.

DYLAN: It's not my thing. What you doing after school Joseph?

JOSEPH: I have a guitar lesson this evening.

HOLLY laughs.

JOSEPH: This is funny?

HOLLY: Who plays the guitar?

JOSEPH: I do.

DYLAN: Only we go down the graveyard most nights. You could come.

HOLLY: He can't. He's got a guitar lesson.

JOSEPH: No, no, that's not until later.

HOLLY: Now look what you done!

CHANTAL: What's wrong with you?

They break out of the scene.

DYLAN: So basically Holly was a bit harsh to Joseph when he first came.

JOSEPH: I was the new boy. At first people don't like you. This is natural.

5 JOSEPH JOINS THE TEAM

Later that day. They are all four in the graveyard after school. JOSEPH is playing his guitar. CHANTAL is enjoying the song and JOSEPH is responding to her. DYLAN is also enjoying it. HOLLY is trying not to enjoy it.

JOSEPH: When trouble comes your way,

You must tell am get away.

When Wahala wants to come,

You must say I be not the one.

(You must say) Everything is alright,

Everything is OK.

Today is a new day,

You must continue to make a way.

(Because) After the high tide, soon comes the low tide,

After the bad news, must come the good news,

After the rainy times, soon comes the sunshine,

After the night time, must come the day time,

HOLLY: When the banjo man starts to play hay,

We all start to pray hay,

That he'll go away hay,

Because he is so gay hay!

DYLAN and CHANTAL laugh but protest.

DYLAN: *(Laughing.)* Shut up Hol!

CHANTAL: You're nasty!

HOLLY: Me nasty?

CHANTAL: I like your song Joseph.

HOLLY: Because after the bad times then come the dark times,

And after the dark times then come the worse times,
And after the worse times then come the crap times,
And you can't see the sunshine, you're buried in shit.

Laughter.

JOSEPH: You're very good Holly. Perhaps we should write some songs together.

He starts to dance around her.

DYLAN: Dance with him Hol!

She dances provocatively turning her back on him and waggling her bottom.

JOSEPH: Is this how girls dance in England?

(Singing.)

Holly is smiling
She thinks I can't see.
She tries to look nasty
But she's nice actually!

CHANTAL and DYLAN cheer.

6 GIRL TALK

February 2009. HOLLY and CHANTAL at school in the break.

HOLLY: He fancies you.

CHANTAL: Who?

HOLLY: Don't say you haven't noticed. Joseph!

CHANTAL: No.

HOLLY: All that smiling he does round you.

CHANTAL: He smiles around everybody.

HOLLY: Do you think he's buff?

CHANTAL: I suppose. Do you?

HOLLY: Ugghhh! No.

CHANTAL: I don't think if I had a boyfriend I'd want him to be black.

HOLLY: Yeah?

CHANTAL: If there was a black boy standing next to a white boy, you know…

HOLLY: You'd go for the white boy.

CHANTAL: Yeah. I don't understand it myself really. It's not like I don't have lots of black men around me who are really good people.

HOLLY: Like the Pastor.

CHANTAL: Yeah.

HOLLY: He says it's harder for black boys because of racism.

CHANTAL: Mmmm.

HOLLY: You know the Pastor says you shouldn't have sex before marriage?

CHANTAL: Yeah.

HOLLY: Does everybody at the Church live by that?

CHANTAL: Everyone has to like act according to their conscience. But we say you should save it till after marriage.

HOLLY: What if you get married and you're like in bed together like on the wedding night –

CHANTAL: Yeah.

HOLLY: And you find out like that you're not right for each other?

CHANTAL: That wouldn't happen.

HOLLY: Why not?

CHANTAL: Because you'd know.

HOLLY: How though?

CHANTAL: You just would.

HOLLY: What if he wants to do things that are like, I don't know, like disgusting?

CHANTAL: What sort of things?

HOLLY: Things.

CHANTAL: What?

HOLLY: I know one girl – she's a friend of my cousin and her boyfriend – my cousin says he's a like a man whore – he wanted her to do things.

CHANTAL: What?

HOLLY whispers in her ear.

CHANTAL: No!

HOLLY: Innit?

CHANTAL: Did she do it?

HOLLY: I don't know. Probably.

CHANTAL: Ugh.

They start giggling.

HOLLY: She probably liked it.

CHANTAL: No!!!

HOLLY: My cousin says she's like proper into this guy.

CHANTAL: No.

HOLLY: Can you imagine?

They giggle more.

CHANTAL: I'd never do that. Would you do that?

HOLLY: No!

More laughter.

HOLLY: She said he'd had a shower first.

CHANTAL: Ugghhhh stop it.

They become hysterical. Eventually their laughter subsides.

CHANTAL: If a boy loved you he wouldn't ask you to do that.

HOLLY: Boys can be disgusting.

CHANTAL: It's like sex is all they think about.

HOLLY: Standard.

CHANTAL: I don't think I want a boyfriend.

HOLLY: Never?

CHANTAL: Not never, but –

HOLLY: Not even if he was white?

CHANTAL: Shut up!

HOLLY: Some girls are just as bad.

CHANTAL: Mmmm.

HOLLY: Most people in our class have done it already.

CHANTAL: That's what they say.

HOLLY: I hate the way everyone wants to know if you've done it yet.

CHANTAL: I prefer being with my friends. I'd rather be with you than with some boy who's gonna be trying to do things.

HOLLY: Awhhhhh.

CHANTAL: It's true. It's more fun.

HOLLY: I never had a friend I could trust before.

CHANTAL: You had Dylan.

HOLLY: I mean a girlfriend. My Aunty always says you can't trust girls to be your friend. She says they'll stab you in the back.

CHANTAL: That's rubbish.

Pause.

HOLLY: She called me a slag last night.

CHANTAL: Why?

HOLLY: Because I got back late. I told her I was down the graveyard with Dylan and she said she knew what we'd been up to and that I was a dirty slag. Cow!

CHANTAL: But you and Dylan aren't like that.

HOLLY: I told her. She didn't believe me.

CHANTAL: Why not though?

HOLLY: She found a leaflet about how to put a condom on a boy. I had it in my bag.

CHANTAL: Why did you have that?

HOLLY: They give it us in Shittyzenshit. Don't mean I'm a slag.

CHANTAL: I know.

HOLLY: Everyone thinks I'm a slag. I ain't never done anything with a boy.

CHANTAL: I don't think you're a slag. They better not say anything like that in front of me.

7 BOY TALK

Spring 2009. JOSEPH and DYLAN (in the changing rooms).

JOSEPH: She's very beautiful.

DYLAN: Who?

JOSEPH: Chantal.

DYLAN: Yeah?

JOSEPH: Don't you think so?

DYLAN: Yeah.

JOSEPH: You don't like her?

DYLAN: Not like that.

JOSEPH: You prefer Holly?

DYLAN: What?

JOSEPH: Do you?

DYLAN: Holly and me go back to nursery.

JOSEPH: And it was love at first sight.

DYLAN: Hate at first sight more like. Apparently I had a toy she wanted and she scratched my face and so I pushed her over and she grazed her knee.

JOSEPH: You are more like brother and sister.

DYLAN: One time we were caught in our back garden with nothing on.

JOSEPH: No!

DYLAN: We were really young. Like five or something. We were in my Dad's shed and we took our clothes off and she made me lie on top of her. My Mum came out to get the lawnmower there we were starkers.

JOSEPH: What happened?

DYLAN: She sent Holly home. I kept saying, 'She made me do it!'

JOSEPH: It is natural for children to experiment. I had a girlfriend when I was twelve. We said we were in love. We kissed. Only that. No nakedness. In Nigeria the girls are not like here.

DYLAN: What you mean?

JOSEPH: In England girls go with boys very easily. It's not like that in Nigeria. They don't want to bring disgrace on their families. So they are more careful.

DYLAN: Like Chantal.

JOSEPH: Yes.

DYLAN: And is that a good thing?

JOSEPH: It's good for the girls. Not so good for the boys.

DYLAN: Is this girl still your girlfriend?

JOSEPH: No. I wanted to go out in the streets and play football. I was more interested in being with other boys than having a girlfriend.

DYLAN: What about now?

JOSEPH: Now the urges are stronger let us say.

He laughs.

DYLAN: Yeah.

JOSEPH: You know what it's like. When you see someone that you like then it's hard to ignore.

DYLAN: So to speak.

JOSEPH: Huh? Oh I see. No I don't mean that kind of hard. Very funny.

He laughs.

JOSEPH: You felt like that yes?

DYLAN: Yeah.

JOSEPH: Now when I see a beautiful girl I think that God has put her there to make me happy.

DYLAN: What if she's fat and ugly?

JOSEPH: If she's fat then that is the devil's work.

He laughs.

JOSEPH: I think the girls really like you. You can talk to them very easily. You have many girlfriends. You are lucky.

DYLAN: Mmmmm.

8 BOY AND GIRL TALK

September 2009. CHANTAL and DYLAN are in the graveyard.

DYLAN: Let's hear it.

CHANTAL: No.

DYLAN: Why not?

CHANTAL: It's no good.

DYLAN: Don't believe you. Go on.

CHANTAL: Turn round. Don't watch me.

DYLAN turns his back on her.

CHANTAL: Without you
　　I knew
　　Only pain without cease.
　　Without you
　　Who do
　　I turn to for peace?
　　You say
　　love may
　　save me today.
　　You're there,
　　you care,
　　they can't take that away.

　　I'm depending on you.
　　I know you'll be true,
　　I see it in your eyes.
　　No pretending to be
　　what I don't want to be.
　　No deceit and no lies

　　Without you
　　I flew
　　without compass or guide.
　　Without you
　　I grew

a fatherless child.
Hold me,
fold me
in your loving arms.
Mould me,
scold me.
I know you'll keep me from harm.

I'm depending on you.
I know you'll be true,
I see it in your eyes.
No pretending to be
what I don't want to be.
No deceit and no lies.

DYLAN: Wow! Who is he?

CHANTAL: What?

DYLAN: The guy?

CHANTAL: Nobody.

DYLAN: Is it someone from your Church?

CHANTAL: It's not anybody.

DYLAN: OK.

CHANTAL: Have you ever felt that about someone?

DYLAN: I'm only fifteen!

CHANTAL: Yeah.

DYLAN: Anyway….

CHANTAL: What?

DYLAN: Everyone's always pretending to be something they're not.

CHANTAL: I'm not.

DYLAN: Aren't there like things you want to cover up and hide from other people?

CHANTAL: Like what?

DYLAN: Haven't you ever done anything you're ashamed of?

CHANTAL: Sometimes I get really angry with my sister. I used the f word once. It's the only time my Mum ever beat me. It was before I was born again.

DYLAN: So now you're born again you never do anything bad?

CHANTAL: I try not to. But if I do, I know Jesus will forgive me.

DYLAN: You really believe that?

CHANTAL: Yes. I think about him up on the cross with the nails in his hands and his feet and the blood running down his face from the thorns sticking in his head. And I think of the Roman soldiers laughing at him and when he asks for water they soak sponges in vinegar and put them on the ends of sticks for him to suck at. Can you imagine? You're dying of thirst and all you get to drink is vinegar? And then I remember that he did that for me. He loves me so much that he's prepared to go through all that pain. He was prepared to die for my sins. It's not just that it makes my troubles seem small in comparison. It's more that if you have that love in your life then nothing else matters. You don't need money or fame or a big house or designer clothes or a fit boyfriend. None of those things matter because you can't take any of those things with you when you die. But you can return to his loving arms. And whatever you do, he'll forgive you. That makes me feel blessed and nothing in this world can hurt me.

DYLAN: I wish I believed in something that strongly.

CHANTAL: I know you don't go to Church or anything. But you're a better person than a lot of people who do. I don't think you've ever done anything bad. Not really bad.

DYLAN: But I might want to.

CHANTAL: Like what?

DYLAN: I don't know.

CHANTAL: It would only be bad if you actually did it.

DYLAN: But if there's something you know you shouldn't do or that you shouldn't feel because it's wrong, but you feel it anyway and think about doing it all the time?

CHANTAL: Maybe you think it's wrong but it's not.

DYLAN: Yeah?

CHANTAL: Maybe it's right for you.

He looks at her. She leans in to him. They kiss.

CHANTAL: That didn't feel wrong, did it?

DYLAN: No.

HOLLY enters.

HOLLY: Hi.

CHANTAL: Hello.

HOLLY: Thought you said you weren't coming down here.

CHANTAL: I met Dylan on the way home from school.

HOLLY: But you said you weren't coming down.

CHANTAL: I know but then Dylan asked me.

HOLLY: I asked you.

CHANTAL: I thought I had to pick up my litte brother but my Mum texted and said she had it covered.

DYLAN: She's written this amazing song.

HOLLY: Yeah?

DYLAN: Sing it for her.

HOLLY: What does someone who's into Will Young know about songwriting?

CHANTAL: Will Young?

DYLAN: That was at Primary School.

HOLLY: I gotta go.

CHANTAL: Has your Aunty been saying stuff again?

DYLAN: What?

CHANTAL: Nothing.

HOLLY: She thinks I'm a slag.

DYLAN: Why?

HOLLY: Because she don't understand that boys and girls can just be friends and not want to bang each other. I mean I know there are some girls that only think about getting a look at a boy's six pack but we're not like that right? She thinks because I've been in trouble at school then I'm going to be doing all sorts of other bad stuff. I said to her it's the quiet ones who are worst. They pretend to be whiter than white but really they're ho's only they're good at hiding it. Laters yeah?

CHANTAL: You want me to come with you?

HOLLY: What do you think?

CHANTAL: I'll phone you.

HOLLY: Whatever.

She goes. DYLAN and CHANTAL look at each other.

CHANTAL: We weren't doing anything wrong.

He looks at his watch.

DYLAN: I'd better be going.

CHANTAL: Yeah?

DYLAN: Said I'd help my Mum in the garden.

CHANTAL: OK.

DYLAN: See you.

CHANTAL: Yeah, see you.

He goes.

9 NATHALIE READS HOLLY'S POEM

NATHALIE reads an entry from the book which was written the same day that HOLLY saw the kiss.

HOLLY: You sat there
so spotless
so clean
with your little gold cross
and polished nails
so far above me.
I couldn't believe you'd have me
as a friend.
Then I made you laugh in class:
the teacher was an ass –
'Hee haw! Hee haw!'
And you saw
and you smiled
and I saw your wild side
that you couldn't hide.
Boom went my heart.
Boom boom boom.
I thought you heard the beat!
I thought you tapped your feet!
You understood!
You always would!
The good girl
was a rebel at heart
and smart.
And that was the start –
smiles and laughter –
and after that
we were never apart.
What does betrayal taste like Chantal?
Like spicy Tarka Dal

45

that you heap into your mouth
and you only realize your mistake
when the hot chillies burn your tongue?
The aftertaste of hell.
What was all that you said about Jesus and sin?
About friendship and trust?
You said I must believe,
only to deceive,
you carbon copy of Eve,
with your racist white boy dream.
Jealousy has green eyes they say
so why do I see red?
I want to hurt you,
subvert your joy,
insert reality
into your girl-meets-boy fantasy.
I will destroy.
I will deploy tooth and claw
in this lipstick war.
And the grass will be crimson
with gore.

She graffitis on a wall: DYLAN BROOKS IS GAY

10 DYLAN'S PAINFUL MEMORY

DYLAN talks about an event that happened a week or so after the kiss.

DYLAN: It was on my way back from school. Joseph had gone
in the shop – he was going to catch me up. I was coming
up to the railway bridge and I saw them up there hanging
around looking at the trains. There was five of them – three
boys from Year Eleven and two from my year – Flakey
Blake and Ashley. Chavs. When I saw them I thought of
going a different way but it would have meant going back
to the main road and that's much longer. When I came up

the steps they went quiet and Ashley said something to one
of the older boys and they were looking at me and smiling
and I thought, 'Something's going to go off.' But I didn't
think anything bad would happen. They were standing in
my way so I had to push past them and they said, 'Oooh,
he thinks he's hard, he thinks he's hard!' Then one of them
said, 'Wait up!' like quite friendly and I looked round. That
was my mistake – you should never look them in the eyes.
He said, 'Is it true?' and I said, 'Is what true?' and he said,
'Your friend Holly says you're gay!' And I said, 'Piss off!' –
something like that and they went, 'Oooooohhh tough guy!'
and by that time they'd got round the other side of me and
I felt someone going in my bag and I pulled away but he
had my Corinne Bailey cd and he was going, 'Who's this?
She your gash, Dilys?' And someone else said, 'Dilys don't
go in for gash. You're queer and we're going to shank you
Dilys.' Stuff like that. And I'm trying to get my cd back
because I thought, 'You're not getting that, my Mum just
bought me that.' And they were holding it up so I couldn't
reach it. And then, and then, then this guy from year 11 –
he's really fat and sly – he throws the cd over the side of
the bridge and it goes down on the track and the others are
laughing and flicking their fingers like they can't believe
he did it. And they were looking at me to see what I would
do. Anyway then Joseph came up and they went quiet.
And Flakey said, 'Hi Joseph!' like all normal and Joseph
said, 'Hi' and they started talking about football because
Joseph's a bit of a star player at school. Anyway so they
just went off and they were like sniggering and the fat one
said like out of the side of his mouth, 'You gonna slip it to
him when you get home, Joseph?' I don't know if Joseph
heard that but he must have seen what was happening. But
we just carried on walking. We didn't say anything about it.
It was like it hadn't happened. It was like – I don't know –
it was like a dirty secret. I wasn't going to tell a teacher or
anything. I'm not a snitch. And I certainly wasn't going to
tell my Mum because I knew she'd go up the school and
make a fuss. And anyway she'd start asking why Holly was

saying that about me. Holly was the only person I might have talked to about it. But seeing as it had come from her...I knew it must have come from her....she'd been blanking me ever since she'd seen me and Chantal down the graveyard...I just felt like there was nobody I could talk to about it.

11 HOLLY AND JOSEPH DRINK CIDER

Late September 2009. HOLLY is drinking Strongbow.

HOLLY: Chantal says you're a backslider.

JOSEPH: Yes?

HOLLY: What does it mean really?

JOSEPH: I think it means someone who stops believing in God and turns to sin.

HOLLY: Why does she say that about you? Is it because you're always late for Church?

JOSEPH: I'm not always late.

HOLLY: Last time I went you didn't get there till the sermon had finished.

JOSEPH: Yes, well sometimes I find it a little bit boring.

HOLLY: I know what you mean.

JOSEPH: But Chantal believes it is not enough to go to Church. You must always live a pure life.

HOLLY: What do you believe?

JOSEPH: I believe that you should try to live a pure life but that is not always possible.

He laughs. HOLLY drinks.

JOSEPH: I think maybe if she saw you with this she would say you are backsliding.

HOLLY: You want some?

JOSEPH: I'm OK.

HOLLY: So you don't drink alcohol but other rules you break.

JOSEPH: I try not to but I don't always succeed.

HOLLY: Pastor says you can't pick and choose, innit?

JOSEPH: It's very difficult.

HOLLY: Chantal's not that perfect.

JOSEPH: What do you mean?

HOLLY: The way she carries on with Dylan.

JOSEPH: Huh?

HOLLY: I caught them down here making out. Didn't you know about her and him?

JOSEPH: Yes. Of course.

HOLLY: So she's a bit of a backslider herself.

She drinks again.

JOSEPH: Maybe I will have some of that.

She hands him the bottle.

HOLLY: I won't tell the Pastor.

He drinks.

HOLLY: If you could have one thing – anything you wanted – what would you wish for?

JOSEPH: I don't know. What would you wish for?

HOLLY: My Mum being better.

JOSEPH: OK.

HOLLY: Going back to live with her. Like it was before. I remember times when it was just the two of us. We were like best friends.

JOSEPH: Eh heh.

HOLLY: So go on.

JOSEPH: I miss my grandmother.

HOLLY: Where is she?

JOSEPH: In Nigeria. She brought me up because my parents were working in England. She was a lovely lady and when I left her I cried. Now she is ill and I don't know if I will ever get to see her again. I would wish to be back there with her.

He hands the bottle back. She takes a swig.

HOLLY: You know like Adam and Eve?

JOSEPH: Yes I know them.

HOLLY: It's like we've all been sent out of the Garden of Eden and we're trying to get back there.

JOSEPH: Not everything in Nigeria is good, but there was more freedom. We had so much fun. All day we were out playing. It was a good life. No gangs, no people wanting to fight with you, no people with knives. Not like here.

HOLLY: Mr Sunshine has got his worries after all. Why do you always pretend that nothing bothers you?

JOSEPH: Because those things are private.

HOLLY: So I should be flattered that you're telling me.

JOSEPH: Perhaps this graveyard is the Garden of Eden and you are Eve tempting me with the apple in your cider bottle.

HOLLY: You think I'm tempting you?

JOSEPH: Definitely.

HOLLY is drunk. She giggles.

HOLLY: There's a place back there in the bushes.

JOSEPH: Yes?

HOLLY: I've got a sleeping bag in there and some more cans.

JOSEPH: A sleeping bag?

HOLLY: Yeah. Not going home tonight.

JOSEPH: You're going to sleep out here?

HOLLY: Maybe. Fancy joining me?

JOSEPH: I have to go to football practice.

HOLLY: After football practice?

JOSEPH: OK.

12 JOSEPH SHARES HIS EXCITEMENT

JOSEPH: Whoa! I was so excited. I was going to become a man! That is what I thought and I walked into the changing room looking so pleased with myself. The other boys said, 'Hey Joseph!' They asked what was happening to me. And I couldn't keep it to myself. I wanted to share my good news. I wanted to boast. It is very hard for me to stand up here before you and tell you what I did. What I was then. At first when Dylan asked me to take part in this show, I was not sure I wanted to talk about these things. But I spoke to my Pastor and I prayed. In the end I decided that this is my penance. To admit my sins in front of our audiences. So anyway I told those boys in the changing room that night that I was going to become a big man. But I was a little boy. I didn't know what I was doing. I was immature. I was thinking about fornication and alcohol. A child pretending to be a man. They wanted details about who and when and where and the little boy told them. And now the man hangs his head in shame.

13 PILLOW TALK

Later that evening. JOSEPH is looking very pleased with himself.

JOSEPH: Aaaahhh That was…that was… Amazing. I've never felt anything like that before.

HOLLY says nothing.

JOSEPH: Are you OK?

HOLLY: Yeah.

JOSEPH: Holly, you know, I really like you. I always have.

HOLLY: Yeah yeah.

JOSEPH: It's true.

JOSEPH hears a noise. He listens.

HOLLY: What?

JOSEPH: I thought I heard something. Maybe next time we can find a better location.

HOLLY: What?

JOSEPH: Somewhere more private. More comfortable.

HOLLY: Who said there's going to be a next time?

JOSEPH: I thought…

HOLLY: What?

JOSEPH: I thought it was good for you.

HOLLY: It was OK.

JOSEPH: Oh.

HOLLY: Your face!

JOSEPH: Oh you got me!

Beat.

JOSEPH: But it was OK?

HOLLY: Yeah. It was banging.

They laugh.

JOSEPH: I have to go.

HOLLY: Alright.

JOSEPH: My Mother has a very suspicious mind. She will want to know why I am late.

HOLLY: That's OK.

JOSEPH: You're really staying here tonight?

HOLLY: I don't know.

JOSEPH: It's not safe.

HOLLY: I'll be alright. I'll probably go home.

JOSEPH: I'll see you tomorrow, yes?

HOLLY: Yeah.

JOSEPH: So…

HOLLY: I'll be alright Joseph.

He goes to kiss her.

HOLLY: What are you like?

JOSEPH: *(Laughing it off.)* Yes. Bye.

He goes.

14 DUET

The characters speak the lines as if at a spoken word event with music and a beat in the background. Lines in bold can be spoken by both characters.

JOSEPH: Walking home in the evening light
The first time I've seen an English Autumn
Leaves falling from the trees
In shades of **green and orange and brown**.

HOLLY: Sitting in the graveyard

Trying not to get spooked
Rustles in the bushes
Shadows and **shapes in the dark**

JOSEPH: Streetlighs coming on now
Somewhere a police car howling
Heart bursting
Head spinning
I did it
I did it
Whooooooo.

HOLLY: Crawling into the sleeping bag
With my torch by my side
A movement in the bushes
Two eyes watching
Who's there?

JOSEPH: Who's there?
Walking into the kitchen and hiding my face
Steam rising from the pan
The smell of spiced lamb
'You're late
you score many goals?'

HOLLY: Heartbeats in my ear
Hardly daring to move
Still they watch me
those spying, shining eyes.

JOSEPH: Walking upstairs to escape
The maternal interrogation
Throwing my muddy football kit
Into the basket on the landing

HOLLY: Slowly slowly moving my hand
Feeling around in the sleeping bag
Don't let him know he's been spotted
Where the hell is that torch?

Ah – got it!

JOSEPH: In the mirror my face looks the same

Something should have changed

'Joseph

You going to let this food go cold?'

HOLLY: Cold.

A fox looking back at me

Just looking

Rude

Bold

A gangster with swagger.

Jesus!

JOSEPH: Jesus looks down from the picture on the wall

As I go downstairs for my tea

Watching me.

But how can this be wrong

When it felt so good?

HOLLY: It felt so…

JOSEPH: Good

HOLLY: It felt so…/cold.

JOSEPH: /Good.

HOLLY: And then he is gone

And I'm alone again

But I still see

His eyes on me

A ghost image

Burnt on my retina.

15 PLAYGROUND WAR

The next day. DYLAN *is holding out a mobile phone.* JOSEPH *and* CHANTAL *are watching a clip on it.*

CHANTAL: That's digusting!

JOSEPH: Where did you get this?

DYLAN: Someone blue-toothed it to me. Look at her. She's loving it.

CHANTAL: Who's the boy?

DYLAN: You can't see.

CHANTAL: That's one of our school blazers.

DYLAN: Could be anyone knowing Holly.

CHANTAL: What do you mean?

DYLAN: She's a slag.

CHANTAL: Delete it.

DYLAN: No way.

JOSEPH: Delete it Dylan.

DYLAN: No point, it's all round school. Look at her face.

CHANTAL: She's your friend.

DYLAN: No she ain't.

CHANTAL: What?

DYLAN: I'm just saying.

CHANTAL: Delete it.

HOLLY enters.

HOLLY: Joseph you wasteman. You're a snake.

She starts hitting JOSEPH.

DYLAN: Hey what you doing, get off him.

CHANTAL: Holly!

HOLLY: *(To JOSEPH.)* You set me up, you shit!

JOSEPH: I didn't know. They must have followed me.

HOLLY: But you told them where you were going?

JOSEPH: I didn't know they were going to follow me.

HOLLY: I don't believe you.

DYLAN: That's perfect.

(To JOSEPH.) This is you?

HOLLY: Why did you have to tell anybody?

She goes to attack him again. DYLAN stops her.

DYLAN: Get off him, Holly. How does it feel to have people saying stuff about you.

HOLLY: Shut up Dylan.

DYLAN: No. I'm enjoying this. This is payback for what you've been going around saying about me.

HOLLY: I ain't said nothing that ain't true.

JOSEPH: Holly, I swear to you. I didn't know they were going to film us, I told them I was meeting you. But I didn't know. Do you think I'd have let that happen if I'd known.

HOLLY: I don't know Joseph. The joke is, I hated it. Every minute of it. It was disgusting, having you on top of me grunting away like a pig. 'Aaaahhhhhh. Oh Holly I really like you.'

DYLAN: Boom!

HOLLY: 'That was amazing. Was it good for you Holly?' No Joseph, I didn't feel a thing. I didn't even know you were there.

JOSEPH: I know for you having sex is no big deal but for me –

HOLLY: What?

JOSEPH: This was not the first time for you.

HOLLY: You what?

JOSEPH: Nothing.

HOLLY: No what you saying?

JOSEPH: At five years old you were taking your clothes off with Dylan.

HOLLY: *(To DYLAN.)*
You tosser.

She goes to threaten DYLAN.

JOSEPH: Come Dylan.

They start to go.

HOLLY: Yeah batty boys go and suck each other's dicks.

CHANTAL: Holly! Stop it!

JOSEPH and DYLAN go.

HOLLY: What you looking at? This is all your fault.

CHANTAL: My fault?

HOLLY: 'I'd rather be with you than with a boy.' Next thing I know you're down the graveyard sucking face with Dylan.

CHANTAL: I didn't know you fancied him.

HOLLY: What? Who?

CHANTAL: Dylan.

HOLLY: You gotta be joking. I don't fancy Dylan. Is that what you think? I'm talking about friendship. I'm talking about loyalty. I'm talking about three being suddenly two and one. I'm talking about betrayal.

CHANTAL: Don't blame me for your –

HOLLY: My what?

CHANTAL: I have always defended you when people said things about you. Now you do this. It makes me look stupid.

HOLLY: Oh well, sorry about that. Sorry it makes you look bad.

CHANTAL: You think I can be your friend after this?

HOLLY shrugs.

HOLLY: It's only bodies.

CHANTAL: What?

HOLLY: We're more than just our bodies, aren't we?

CHANTAL: If you think that what you do with your body doesn't matter then there's no hope for you.

CHANTAL goes.

16 AN INTERUPTION

DYLAN: Sorry guys…um…sorry everyone…um…I just wanted to say something. Can I say something? [Julia] [Stage manager's name] is it alright if I say something before we do the next bit? Sorry. It's just that there's a part of the story that I've never told you guys. I'm finding it hard to sit through this bit when I know that I haven't told you what happened the next night. Watching it [tonight] [today] I suppose I feel I should tell you. So is that alright?

JULIA/STAGE MANAGER gives the go ahead.

DYLAN: Umm yeah so the next day Holly didn't come into school and um everyone was still talking about the video of her and Joseph. My cousin who goes to another school had seen it – it sort of went viral. So anyway that following night Holly came to my house. At that point my Mum didn't know about what was going down and she just sent her up to my room. I mean I was still mad at her but if I chucked her out, my Mum would want to know why. So she came in and she wanted to talk. She wanted to talk to me about…uhhh…about her feelings for you Chantal.

Umm…she was very confused but – well what she said was that it wasn't Joseph that she wanted to be with, not really.

CHANTAL: Shouldn't we talk about this afterwards?

DYLAN: She said that she had these feelings for Chantal that she didn't understand and did it mean she was a lesbian and stuff.

JOSEPH: Dylan, I think we should/ just do what we have rehearsed.

NATHALIE: /Joe.

JOSEPH: Yes?

DYLAN: She said she had these feelings and was it wrong? And should she tell Chantal? And what would the Pastor say? She said that I was the only person that would understand. And I asked her what she meant. I knew where she was going but I was….she said, 'Because you're gay and you'll understand.'

JOSEPH: *(Amused.)* Tcha.

DYLAN: And the thing was…um…I told her I didn't know what she was talking about…um that she'd got it wrong and how dare she go round telling people that I was gay? And yeah, it was like, I totally denied it. I was scared I suppose. I knew what it would be like in school if I…in fairness I was only fifteen and now at nineteen I'm more sure of who I am. But what I can't forgive myself about is that I told Holly that I wasn't gay, which was a lie. Because I am. I am gay. Yesterday my boyfriend came to see the show and –

NATHALIE: The mixed race guy from the pub?

DYLAN: Yeah!

NATHALIE: I knew it! He was nice.

CHANTAL: Nathalie! Can we just…

DYLAN: Anyway last night we talked about it and he thinks I owe it to you guys to tell the truth. I mean there were several times in rehearsals when I thought about it and Julia said something about sexuality – so I think [she] [you] guessed [didn't you, Julia?]

NATHALIE: I guessed.

DYLAN: But anyway I was still too scared to come out to you guys. I didn't know how you'd take it. But yeah I'm doing it now because I'm not ashamed of it any more and I want you to know the truth about Hol.

JOSEPH: Have you finished?

NATHALIE: Joe!

JOSEPH: Can we finish the play now? [Julia] this isn't what we have come here for.

DYLAN: What do you mean?

JOSEPH: You're standing up in front of all these people talking about homosexuality. There are young people in the audience who are very impressionable.

DYLAN: Yeah and maybe some of them are gay.

JOSEPH: [Julia] [Stage Manager's name] please, I didn't sign up for this.

DYLAN: Maybe some of them are having the same problems that Holly and me were having at school – hiding, feeling split.

JOSEPH: This is wrong.

DYLAN: Why?

CHANTAL: Dylan!

JOSEPH: Because homosexuality is wrong. It is a sin. It says so in the Bible. 'Thou shalt not lie with mankind as with womankind, it is abomination.'

DYLAN: And everything in the Bible is true is it?

JOSEPH: It is the word of God.

DYLAN: Yeah but it's written by people.

JOSEPH: 'The unrighteous shall not inherit the kingdom of God. Be not deceived, neither fornicators, nor idolaters, nor adulterers, nor effeminate, nor abusers of themselves with men.'

DYLAN: Abusers?

JOSEPH: Yes it is abuse. Dylan we were friends. I have been naked before you!

DYLAN: What?

JOSEPH: We have changed in front of each other in the school changing rooms.

DYLAN: It's alright Joseph I wasn't looking.

JOSEPH: *(Horrorstruck.)* Ugh!

DYLAN: Anyway I didn't fancy you!

JOSEPH: No?

DYLAN: No.

CHANTAL: *(Looking at [Julia] [Stage Manager].)*
Can I say something?

[Julia] [Stage Manager] nods.

CHANTAL: Joseph, it also says in the Bible that it is a sin to wear clothes made of different sorts of fabrics and to have tattoos – you used to be a big fan of David Beckham but he's damned – and I think I saw you having a bacon sandwich the other day. Eating pork is a sin too.

JOSEPH: These are small things.

CHANTAL: Yeah but that's what it says. The Bible was written a long time ago. Those were very different times.

JOSEPH: Does the Pastor know you hold these beliefs?

CHANTAL: The Pastor once told me that in the end your conscience is more important than anything.

JOSEPH: [Julia] [stage manager] I'm sorry. I can't stay here and be part of this. This is wrong.

(To CHANTAL.) You are casting doubt on the word of God.

JOSEPH starts to leave the stage.

NATHALIE: Isn't there something in the Bible about casting the first stone?

CHANTAL: Yes.

NATHALIE: What is it?

CHANTAL: It's about a woman who was going to be stoned to death for committing adultery and Jesus said to the crowd that the person without sin should cast the first stone.

NATHALIE: Right. So Joe, how can you stand here and judge people like this?

JOSEPH: Nathalie, please, this is different.

NATHALIE: No come on, if what you say is true and that we have to go by everything that it says in the Bible then we've been sinning for the last two weeks.

JOSEPH: That is personal.

NATHALIE: Do you see it as sin? Because I don't. I think it's beautiful. And fun. And good. But maybe I shouldn't have asked you in for that coffee. Maybe I should have sent you home that night. Maybe I should be stoned for letting you into my bed.

Silence as the others take in what she is saying. JOSEPH is frozen.

JOSEPH: We must have standards even if we cannot live up to them. Yes I am a sinner. We are all sinners. But that does not mean we should give up trying to live a pure life. The more I live in this country, the more I see people living empty lives. That is the hole we are talking about in this play. They try to fill it with possessions and money and sex

and alcohol and drugs and celebrity and reputation. And the more desperately they chase after these worldly things, the more desperate they feel. Because there is not enough money in the entire world to fill that emptiness. They steal, they become addicts, they cheat on their partners. If someone harms their reputation they take a knife and kill them. They try to fill the emptiness with illusions. I believe that the Bible offers us another way: that is all; a way to live where we follow God's divine laws; where we respect our bodies and our lives and the bodies and lives of others. But it is hard and we sometimes fail. And there will always be people who point to priests who do bad things, and use that as an excuse not to try to be good themselves. Or who say, 'Ah yes but in the real world you can't live like that.' But those are the devil's words. Until we give ourselves to the Lord we will never be content and the emptiness will remain inside. We have to welcome Jesus into our hearts and follow his teachings and the teachings of the prophets. Only then will we enter the true Kingdom. Only then will we be filled with God's Grace. For me that is the meaning of Holly's story. She was trying to fill the emptiness with the wrong things.

CHANTAL: What about love Joseph?

JOSEPH: Oh come on.

CHANTAL has found a Bible in her bag and has been looking for a quotation.

CHANTAL: 'If I speak in the tongues of men or of angels, but do not have love, I am only a resounding gong or a clanging cymbal. If I have the gift of prophecy and can fathom all the mysteries and all knowledge, and if I have a faith that can move mountains, but do not have love, I am nothing. If I give all I possess to the poor and give over my body to hardship that I may boast, but do not have love, I gain nothing.' Holly had heard all the teachings from the Bible. But it didn't save her.

JOSEPH: Because she didn't listen.

CHANTAL: I wish Holly was still here. Maybe she wouldn't have done what she did if people had shown her a bit more love. She must have been desperate. If she was gay then she needed to be able to –

JOSEPH: She wasn't gay.

CHANTAL: How do you know? Maybe she was.

JOSEPH: Then she needed help to put her back on the right path.

CHANTAL: I don't care if she was or if she wasn't. I miss her. I wish I could tell her that. Maybe that was what she needed. Someone who was going to accept her as she was. Instead we all judged her. She was our friend and we let her down.

JOSEPH packs up his things.

NATHALIE picks up a stone from the graveyard and hands it to JOSEPH.

NATHALIE: Take it.

He takes the stone.

The others look at him. NATHALIE picks up HOLLY's book.

NATHALIE: Let's carry on.

She indicates to the sound desk and sound comes on.

17 HOLLY'S SUICIDE NOTE

The evening of the conversation with DYLAN at his house. HOLLY enters with her rucksack. She looks around the graveyard. She gets out her sleeping bag.

HOLLY sits down. She takes out her last can of Strongbow.

HOLLY: Are you still down there
Samantha Barnes,
Born 1944
Died 1959?

Did someone cry
for you in that time gone by?
Samantha Barnes
'rests in the arms of her Heavenly Father'.
And did her earthly father grieve
that she had to leave the party
just when it was beginning?
Was it sinning that brought her down,
down
into the dark earth?
And does she still feel the weight
of earth and stones?
Are her bones still there
as she sleeps alone
through the years?
Does anyone remember
her footsteps on the stair,
her tangled hair
fair eyelashes
and dark eyes?
Are you there
Samantha Barnes?
Who cries for you now?
Is there still a hole in someone's life?
Should you have been someone's wife
or mother?
Is there a grieving brother –
a lover perhaps?
Were you the other woman that never was?
Some people leave a space,
and some just slip away,
and leave no trace,
and the world is a better place
without them.

She takes out her notebook and writes.

What am I to do
my true friend
my boo?
Without you
I'm nothing.
This is better –
for me
and for you too.

She takes out pills and puts them in her hand. Takes them and swigs back some cider.

Sirens.

DYLAN finds the sleeping bag and sees the book inside it.

He picks up the book and reads.

JOSEPH starts to hit himself.

CHANTAL prays.

CHANTAL sings the Gospel song 'Down in the River to Pray'.

18 THE FINAL ENCOUNTER

January 2011. NATHALIE puts on a short coat and pulls up her skirt to reveal her legs. Sound of cars. HOLLY watches them pass.

After a moment CHANTAL enters. She is wearing a coat too.

CHANTAL: Holly.

HOLLY: Oh hi.

CHANTAL: I didn't recognize you. How are you doing?

HOLLY: Yeah good. You?

CHANTAL: Yeah. Long time no see.

HOLLY: Yeah. You still at school?

CHANTAL: Yeah started doing my A levels.

HOLLY: You going to Uni?

CHANTAL: Maybe. I'm thinking of taking a year off after school. There's a charity working with children in Cameroon. I might go and volunteer for a while with Tunde.

HOLLY: Who's Tunde?

CHANTAL: My boyfriend.

HOLLY: Tunde.

CHANTAL: Yeah I know. He's Nigerian.

HOLLY: From Church?

CHANTAL: No, he's not a Christian. I'm working on that.

HOLLY: Pastor must be disappointed.

CHANTAL: Maybe. You seen Dylan lately?

HOLLY: No.

CHANTAL: He's talking about going to drama school.

HOLLY: He's going to be an actor?

CHANTAL: So he says.

HOLLY: What about Joseph?

CHANTAL: He says he's going to study engineering.

HOLLY: Engineering!

CHANTAL: Either that or theology.

HOLLY: What happened to playing for Chelsea?

CHANTAL: Hol, I tried to visit you when you were in hospital.

HOLLY: I know.

CHANTAL: They wouldn't let me in.

HOLLY: I wasn't feeling like having visitors.

CHANTAL: No.

HOLLY: Couldn't even top myself properly.

CHANTAL: You know Joseph had a big fight with Flakey Blake about what happened.

HOLLY: I heard.

CHANTAL: Then Ashley and Flakey Blake got expelled 'cos of all the Facebook stuff?

HOLLY: Yeah.

Beat.

HOLLY: When I come out of hospital, I went on Facebook. I don't know why. And someone had pasted a picture of a bottle of paracetamol tablets saying, 'Try these next time.'

CHANTAL: That's terrible.

HOLLY: Yeah well. That's what people are like.

CHANTAL: But you're ok now?

HOLLY: Sink or swim, isn't it?

CHANTAL: Look why don't you give me a ring?

HOLLY: Lost my phone and all my numbers.

CHANTAL: Dylan's got your book with all your lyrics and stuff. You left it down the graveyard.

HOLLY: Oh right.

CHANTAL: Have you got a new number?

HOLLY: Yeah.

CHANTAL: Here.

She finds her contacts file and hands her phone to HOLLY. HOLLY takes it and enters a number.

CHANTAL: What you doing now? Fancy a coffee or something?

HOLLY: I'm working.

CHANTAL: What? Oh. Oh right.

HOLLY: There's a car over there. The driver's been looking at us for the last five minutes. So I think I'd better go and see what he wants. Unless you want to.

CHANTAL smiles nervously.

HOLLY: Thought not.

CHANTAL: Well, I'll give you a ring, yeah?

HOLLY: Yeah.

She starts to go.

HOLLY: Like I said, it's only bodies, Chantal. It's not like anyone's gonna die.

CHANTAL: Right.

HOLLY goes towards the car. NATHALIE stops in front of JOSEPH who is still holding the stone. She stares at him. In the end he turns away and puts the stone down.

CHANTAL: That was the last time any of us saw her. I tried phoning her but the number she gave me was for a taxi firm. They'd never heard of her.

DYLAN: I phoned up her Aunty. She was really unfriendly. Said she hadn't seen Holly for over a year. Said she didn't want to. Apparently she got burgled and she thinks Holly was behind it. Said Holly probably needed some drug money.

JOSEPH: Our school football team played Ashley's school and Ashley was saying he'd heard that Holly had died of a drug overdose. But given the dubious source of the information I'm hoping and praying that this is not true.

CHANTAL: Someone said she'd got a job with the youth services up North somewhere working with young people at risk.

DYLAN: Someone said she'd moved to California and was writing lyrics for a band in LA.

JOSEPH: Someone said they saw her on TV camping outside St Paul's Cathedral with the Occupy protesters.

CHANTAL: Wherever she is, I hope she's at peace.

DYLAN: I hope she's happy.

JOSEPH: I hope she's whole.

Reprise of opening song.

OTHER PHILIP OSMENT TITLES